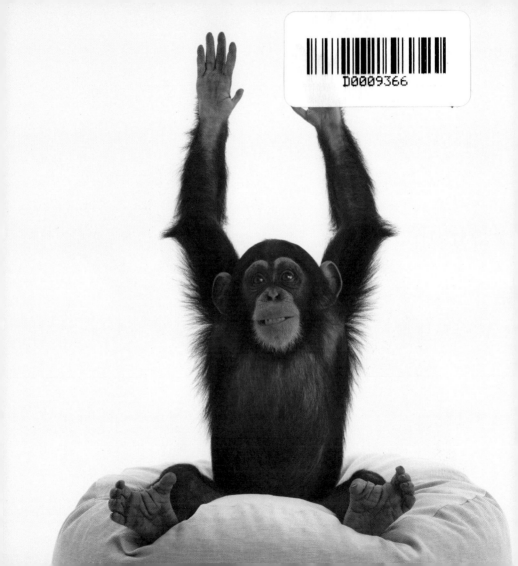

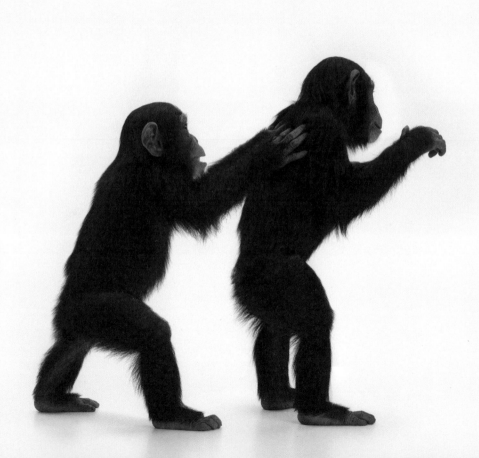

THE TWO OF

US

WHY I'M NUTS
ABOUT YOU

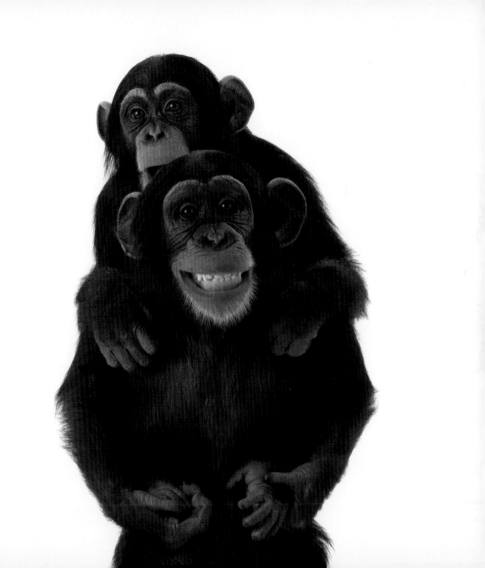

THE TWO OF
US
WHY I'M NUTS
ABOUT YOU

Bob Elsdale and Holly

Text by Patrick Regan

**Andrews McMeel
Publishing, LLC**
Kansas City • Sydney • London

in association with PQ Blackwell

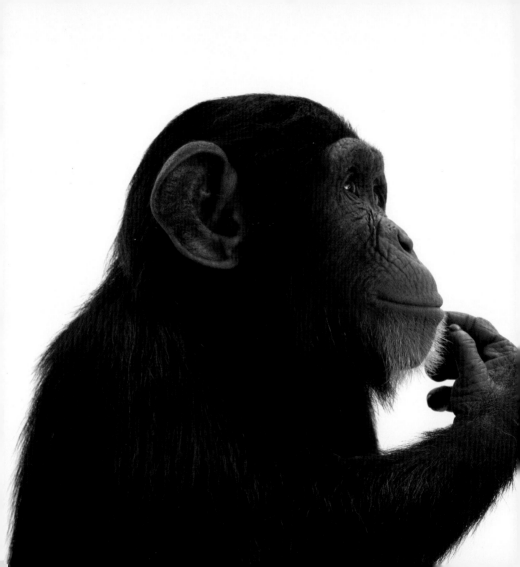

LET'S SEE ...

WHERE DO I BEGIN?

BEING WITH YOU MAKES ME HAPPY
BECAUSE YOU ARE ... WELL,

YOU'RE NOT LIKE ANYONE ELSE.

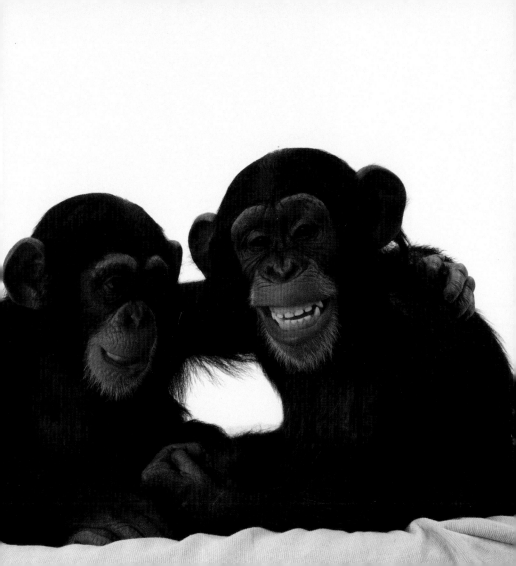

THAT'S FOR SURE.

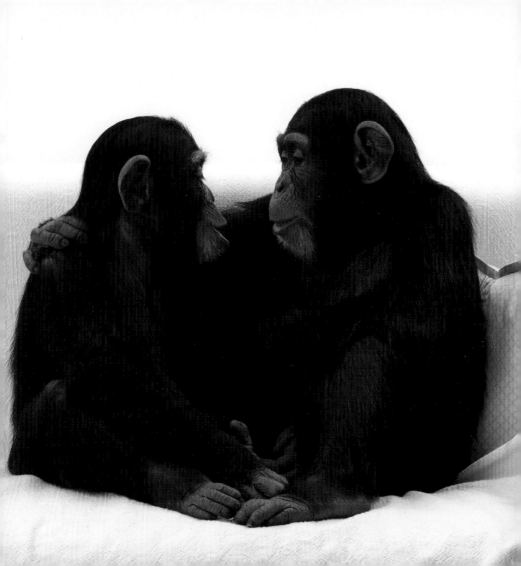

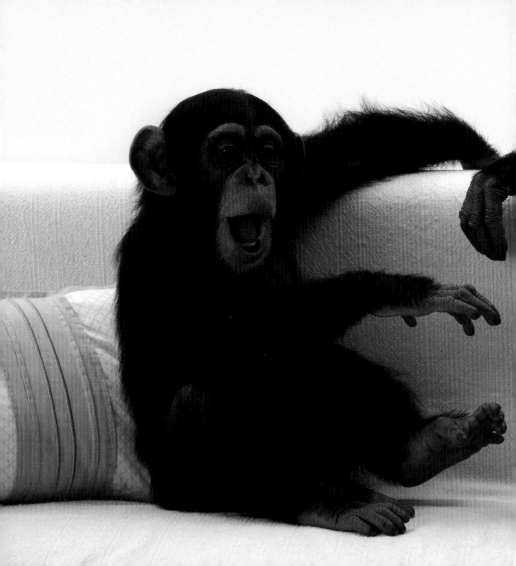

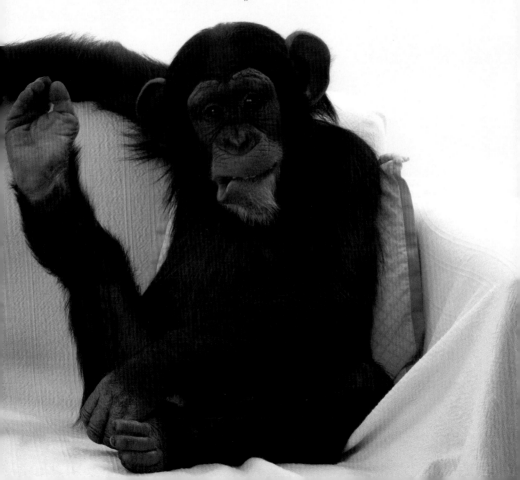

WAIT! THAT DIDN'T COME OUT RIGHT.

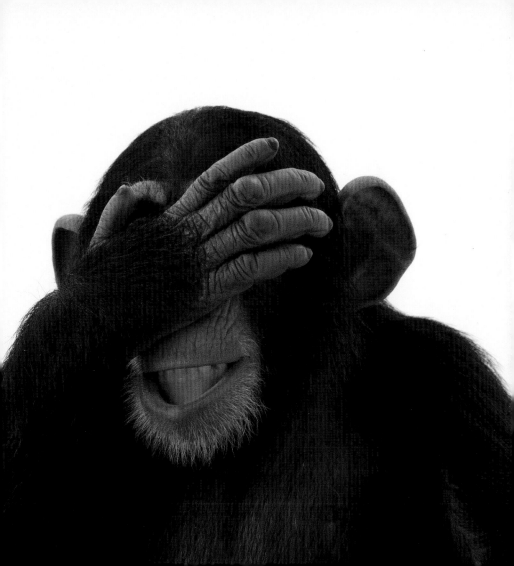

UNIQUE! THAT'S WHAT YOU ARE. UNIQUE.

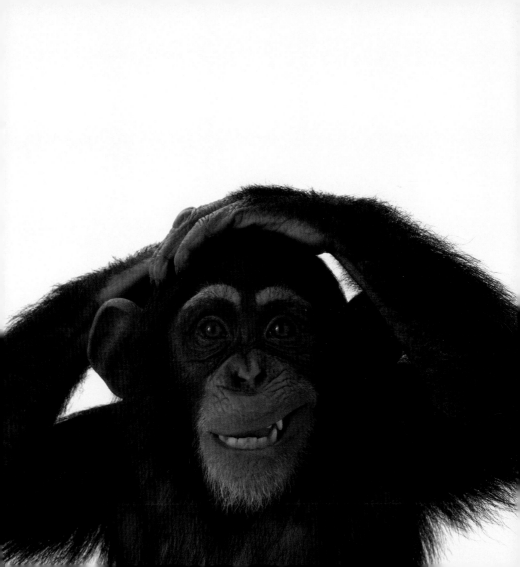

YOU'RE AN EXTREMELY

GOOD LISTENER,

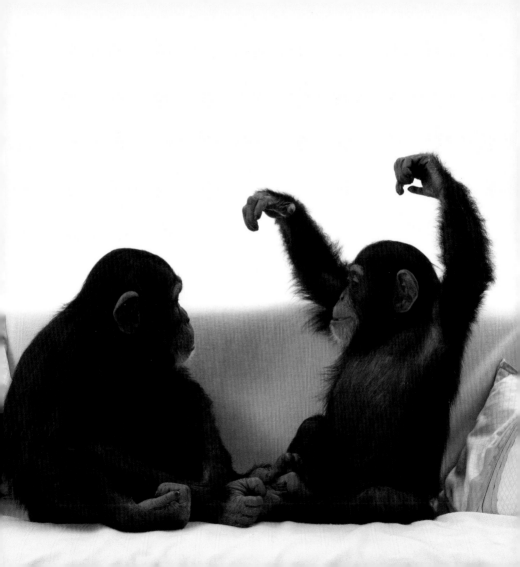

WHICH IS HANDY
'CAUSE I'M AN EXTREMELY

GOOD TALKER.

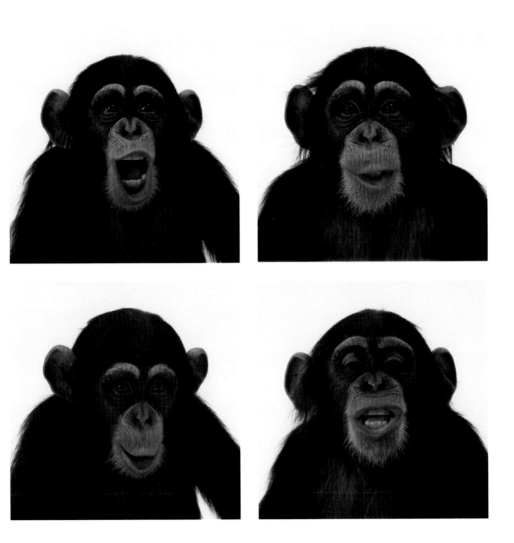

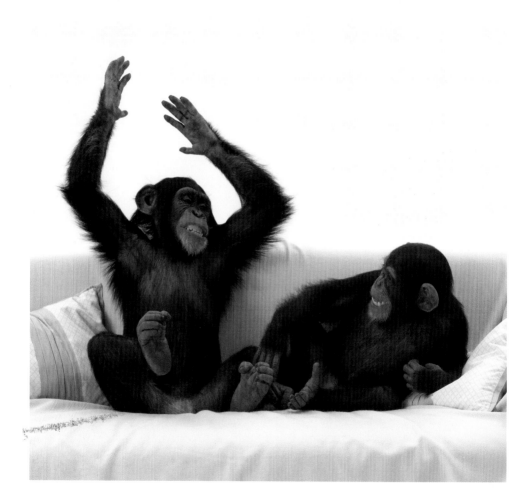

YOU KNOW HOW TO

TELL A JOKE.

BUT YOU ALSO THINK

DEEP THOUGHTS.

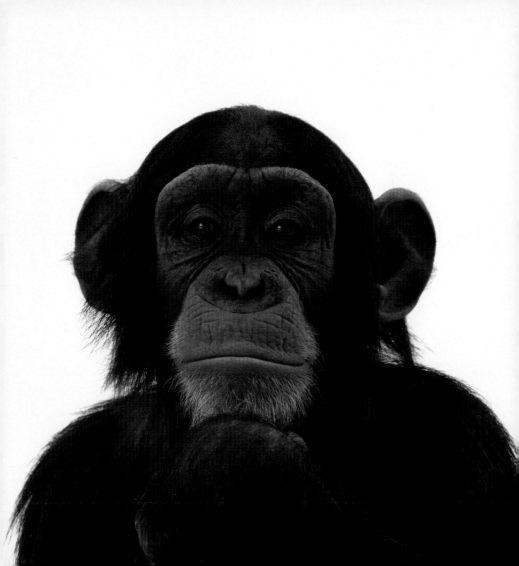

YOU'RE NOT AFRAID TO ADMIT

YOUR MISTAKES ...

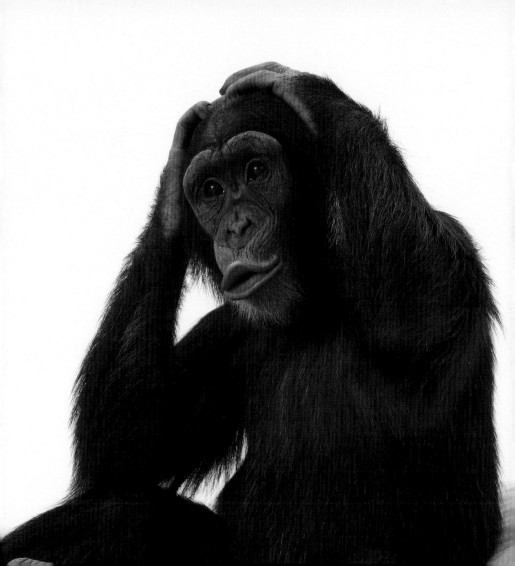

OR POINT OUT MINE.

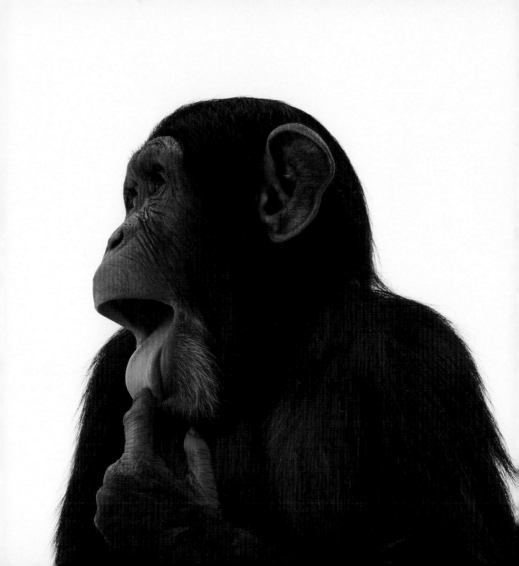

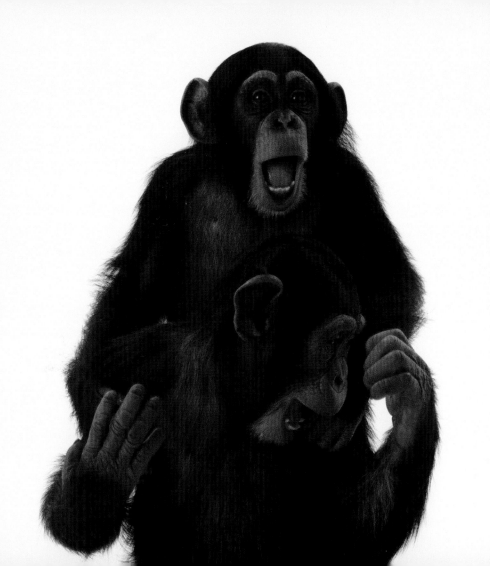

**YOU HAVE A NAUGHTY
SENSE OF HUMOUR,**

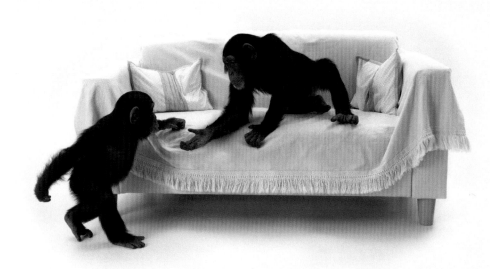

BUT AN UNWAVERING SENSE

OF RIGHT AND WRONG.

IT'S TRUE. THERE ARE ENDLESS
REASONS WHY BEING WITH YOU

MAKES ME HAPPY.

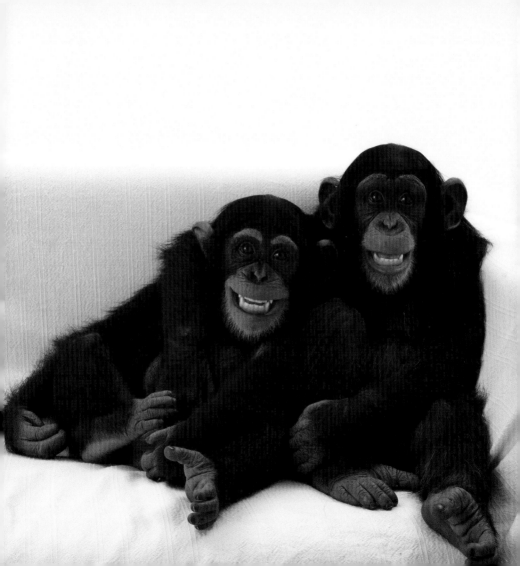

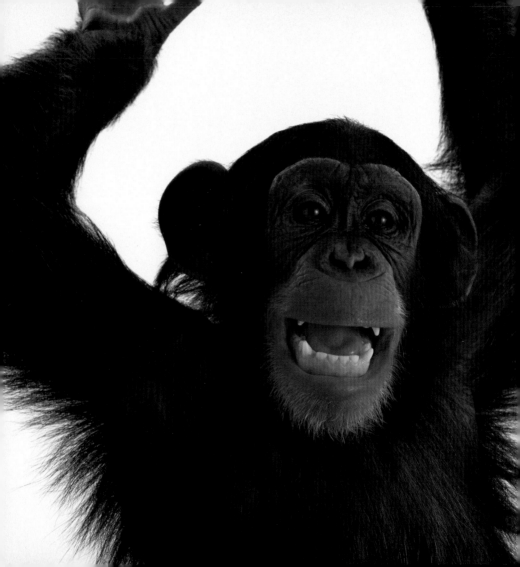

YOU'RE CONTAGIOUSLY

ENTHUSIASTIC,

UNABASHEDLY
AFFECTIONATE,

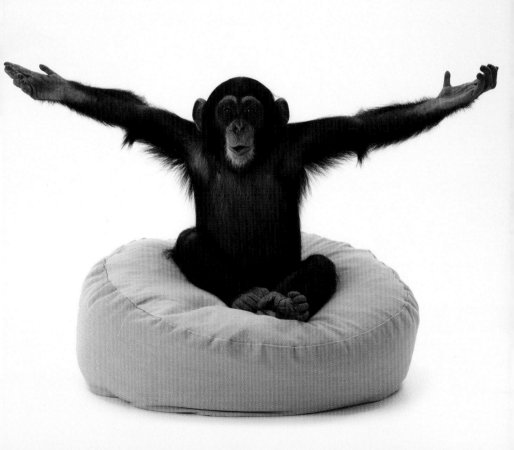

FIERCELY
PROTECTIVE

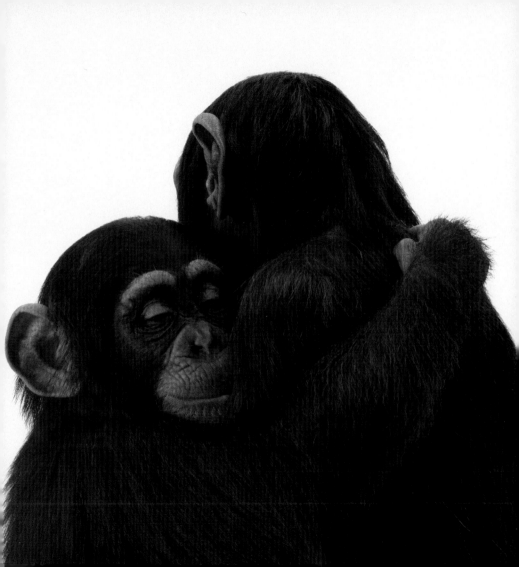

AND ENDLESSLY

ENTERTAINING.

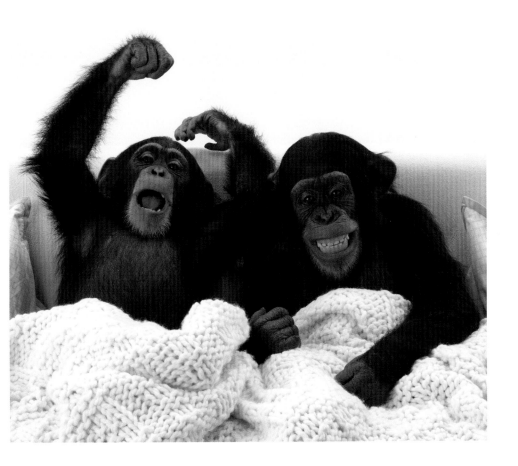

YOU NEVER LET THE FACT THAT YOU DON'T
KNOW ALL THE WORDS KEEP YOU FROM

SINGING YOUR HEART OUT.

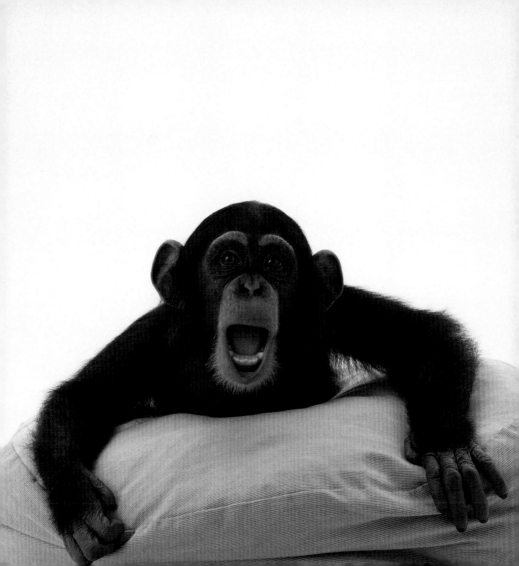

I LOVE THAT ABOUT YOU.

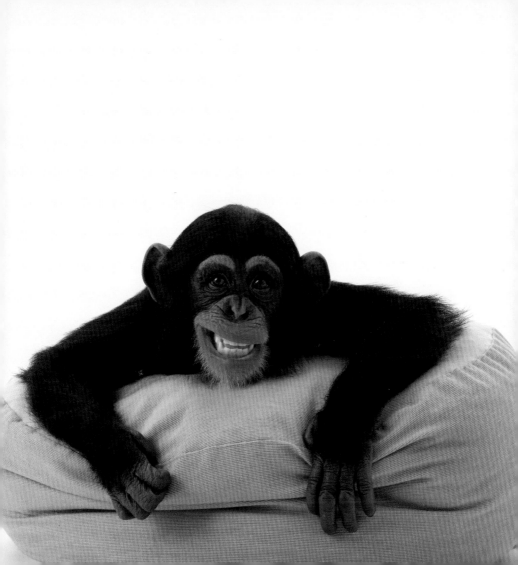

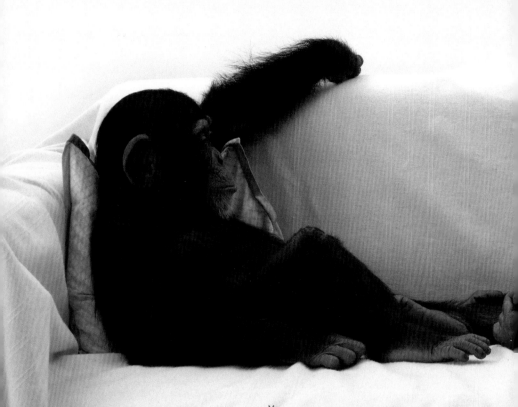

AS CLOSE AS WE ARE, IT'S HARD FOR

EITHER OF US TO SURPRISE THE OTHER,

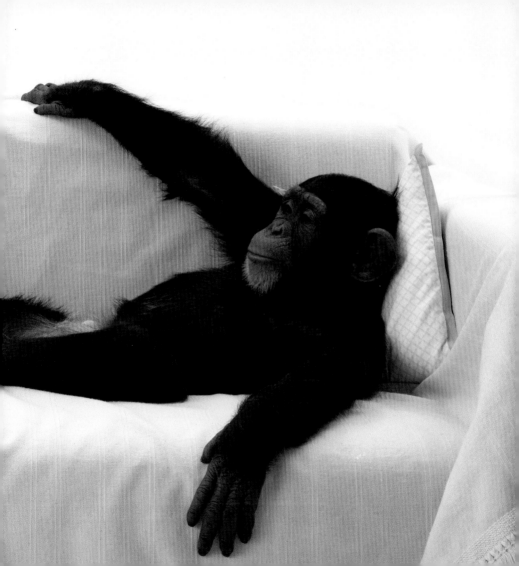

BUT I LOVE THAT WE BOTH

STILL TRY EVERY SO OFTEN.

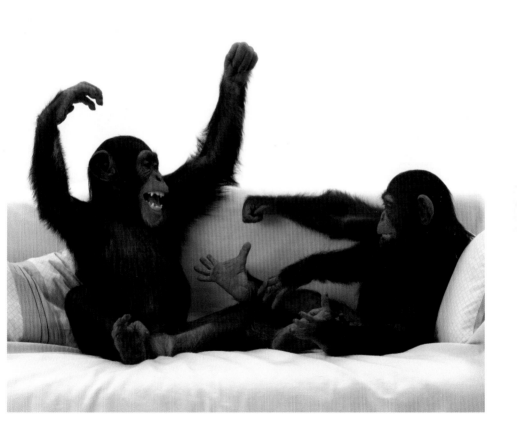

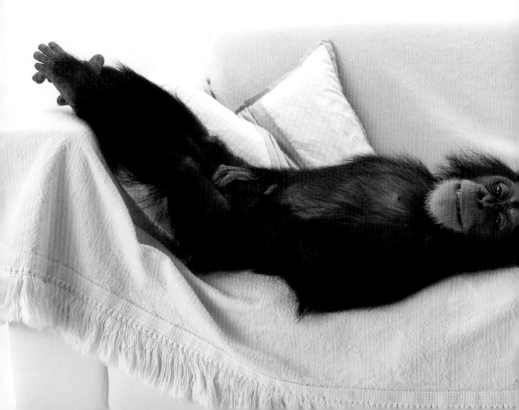

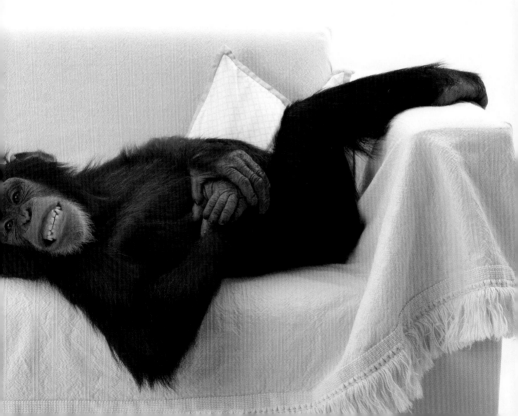

I LOVE YOUR MISCHIEVOUS STREAK ...

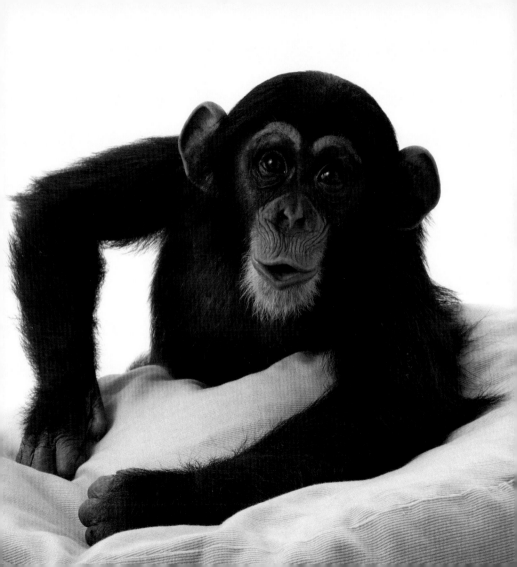

EVEN IF IT HAS GOT US INTO

TROUBLE ON OCCASION.

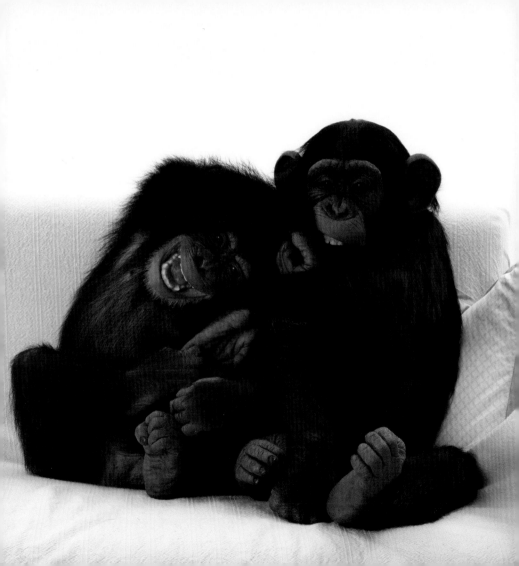

AND WHEN WE GET DOWN

TO SERIOUS TALK,

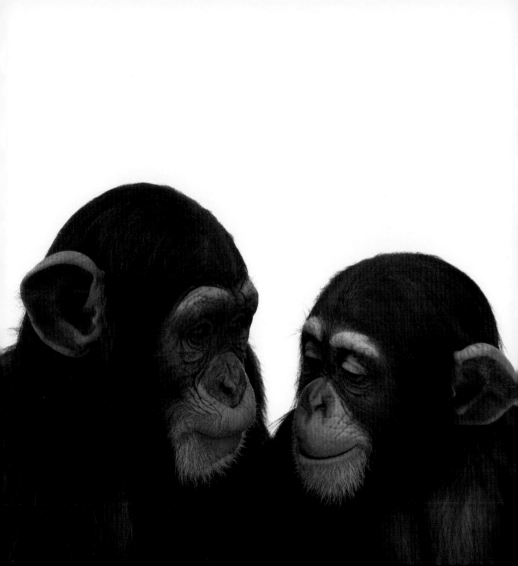

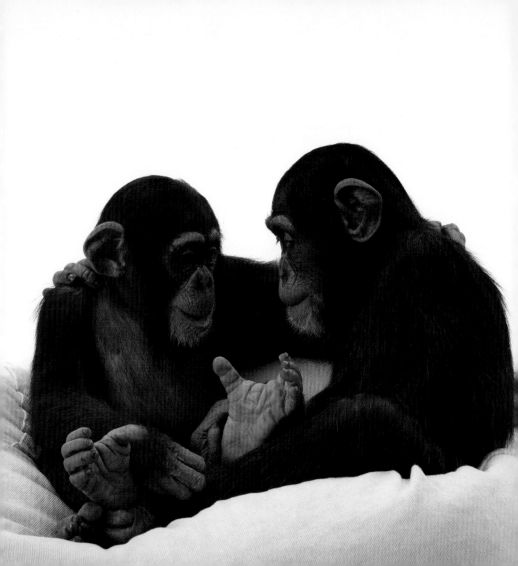

I LOVE THAT THERE ARE

NO FILTERS OR TABOO SUBJECTS.

WE CAN SAY ANYTHING
TO EACH OTHER, A LOT OF THINGS,

WITHOUT SPEAKING A WORD.

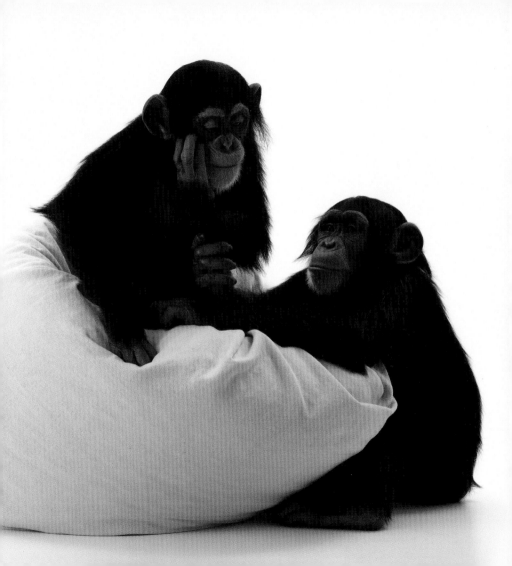

OF COURSE, BEING INDEPENDENT THINKERS,

WE DON'T ALWAYS SEE EYE TO EYE.

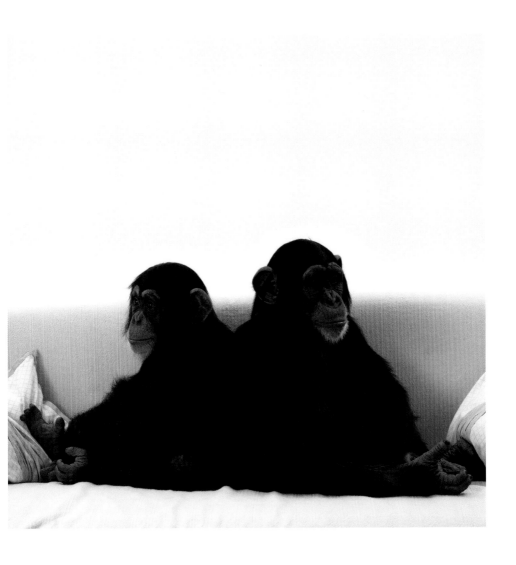

BUT IT NEVER TAKES LONG TO
RECONCILE OUR DIFFERENCES

HEART TO HEART.

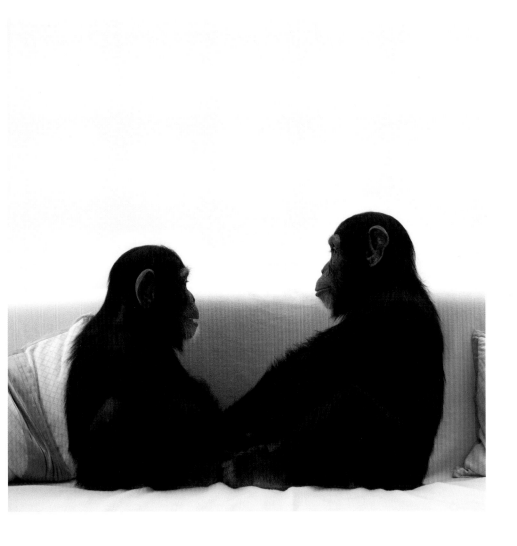

THE SIMPLE TRUTH IS, WE'RE JUST

BETTER TOGETHER.

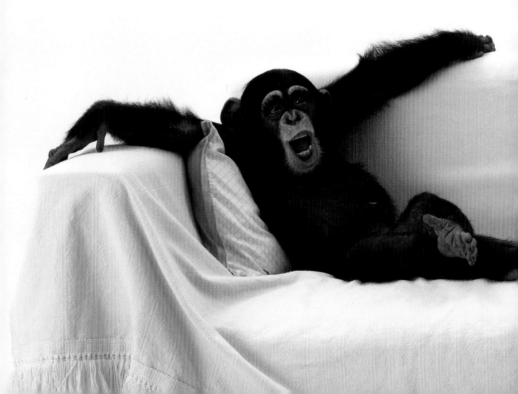

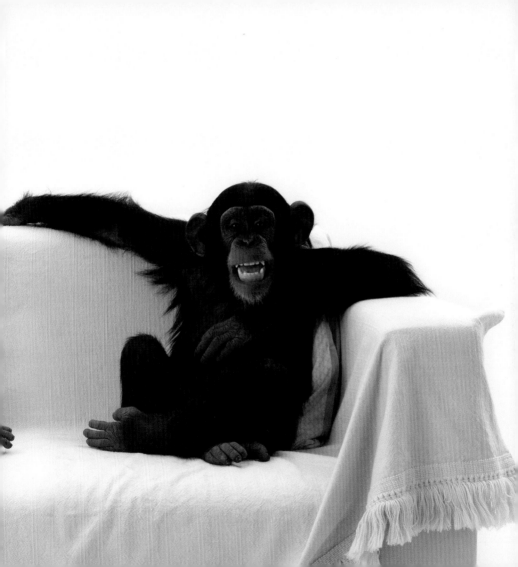

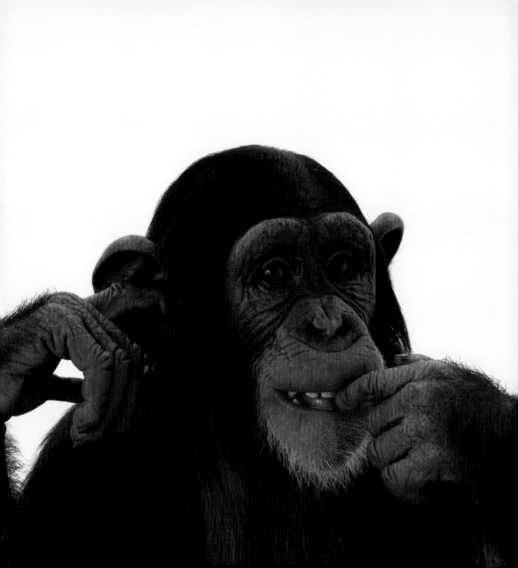

LIKE I SAID, IT'S HARD TO KNOW
WHERE TO BEGIN WHEN TALKING

ABOUT ALL THE REASONS ...

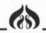

I'M NUTS ABOUT YOU.

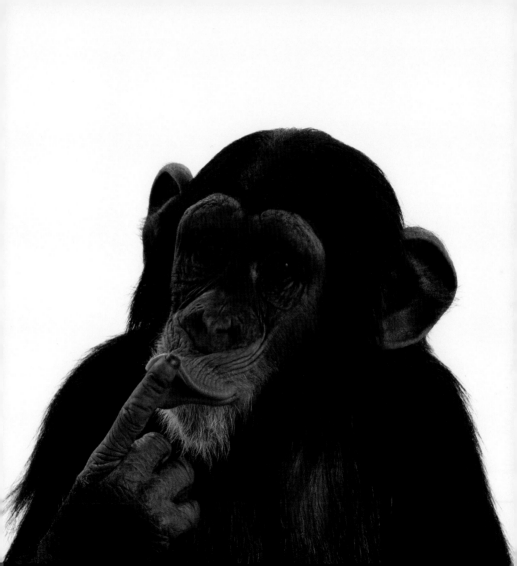

⌘AND IT'S EVEN ...

HARDER TO STOP.

HONESTLY, THERE'S ONLY ONE THING THAT MAKES
ME HAPPIER THAN THINKING ABOUT ALL THE

WONDERFUL TIMES WE'VE SHARED ...

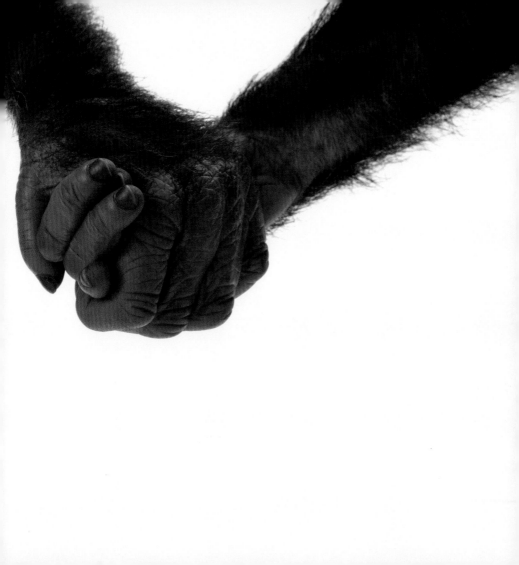

THAT'S THINKING ABOUT ALL THE

FUN STILL AHEAD.

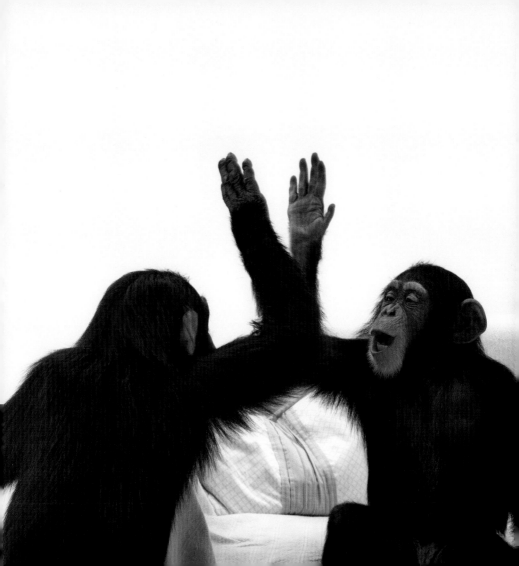

THANKS FOR ALL THE GOOD TIMES,
AND FOR BEING A FRIEND

LIKE NO OTHER.

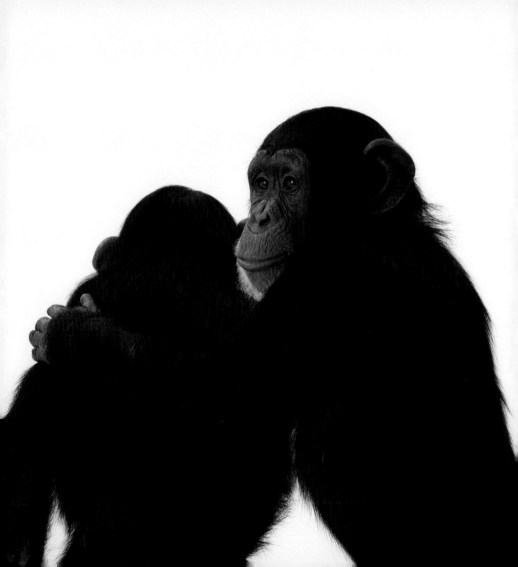

THE END

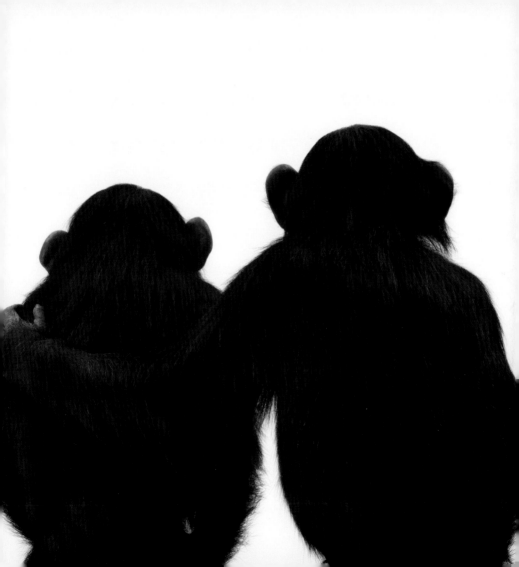

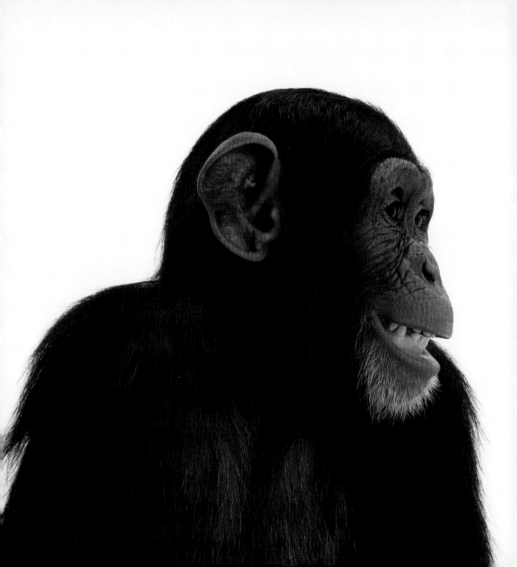

ACKNOWLEDGEMENTS

To chimpanzees Kenzy and Willie for being absolute stars on and off the set! It was an experience I will never forget.

To trainers Greg Lille of People And Chimps Together (P.A.C.T.) and Mike Casey of Missouri Primate Foundation for making this book possible. Their insight and understanding of primate behaviour was both fascinating and invaluable in helping to achieve some fantastic shots. Alongside this, their commitment to the welfare of their chimpanzees made us feel very at ease throughout the week we spent working with them.

To Holly, my daughter and art director, for her help in conceptualizing and styling the imagery, as well as her eagle eye on set.

To my wife, Christine, for always being on hand to deal with any kind of crisis before it even started.

To Sam Kweskin and Curtis McElhinney; it was great to work with them again, with Sam taking great care of all the digital capture and Curtis the lighting management.

To Rinat Greenberg and her team at Miauhaus Studios, Los Angeles, who did everything to facilitate a seamless shoot.

Bob Elsdale

PACT
A PRIMATE PRESERVE

As caretakers of this planet, we must take responsibility for its natural resources and inhabitants. We must provide for those who cannot provide for themselves. So goes the contemporary relationship between man and the great apes.

Greg and Carol Lille formed People And Chimps Together (P.A.C.T.) in 1996 to ensure the well-being and lifelong care of chimpanzees that work in the entertainment industry. P.A.C.T. is a partnership between people and apes that is securing funding to build and maintain a sanctuary for retired chimpanzees. This sanctuary will provide a safe and humane environment where chimpanzees can live out their entire natural lives.

The two chimpanzees featured in *The Two of Us*, Willie and Kenzy, represent two of the many chimpanzees that P.A.C.T. is dedicated to caring for. It is P.A.C.T.'s desire that both Willie and Kenzy continue to live with their natural parents and enjoy a social life with their chimpanzee peers.

Chimpanzees can live up to sixty years. If you would like to find out more about P.A.C.T. or how you can make a donation, visit their Web site at www.chimppact.org or e-mail pact@calwisp.com.

This edition published in 2011 by Andrews McMeel Publishing, LLC, an Andrews
McMeel Universal Company, 1130 Walnut Street, Kansas City, Missouri 64106.

ISBN: 978-0-7407-7951-0
Library of Congress Control Number on file

www.andrewsmcmeel.com

Produced and originated by PQ Blackwell Limited
116 Symonds Street, Auckland, New Zealand
www.pqblackwell.com

Text: Patrick Regan
Artwork design: Carolyn Lewis

Five percent of the originating publisher's revenue from the sale of the book will
be donated to People And Chimps Together (P.A.C.T.).

Printed by Everbest Printing International Ltd, China.

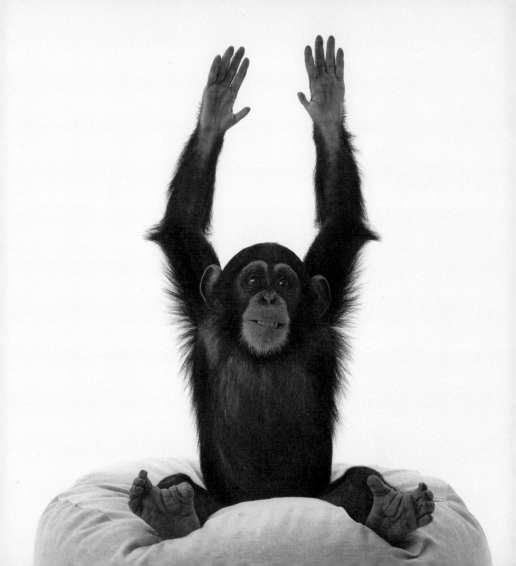